T0209553

The
Mystery & Marvels of Nature in Rhythm & Rhyme

Melody Hamby Goss

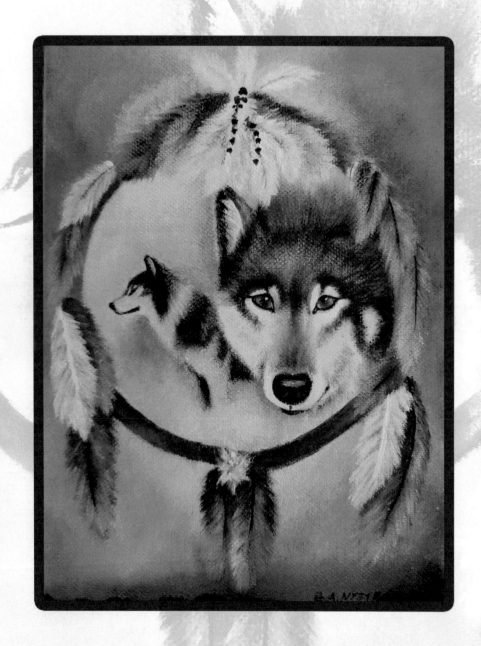

Illustrator - Gerd Annie Nystrom

AuthorHouse™
1663 Liberty Drive
Bloomington, IN 47403
www.authorhouse.com
Phone: 1 (800) 839-8640

*This is a work of fiction. All of the characters, names, incidents, organizations, and dialogue
in this novel are either the products of the author's imagination or are used fictitiously.*

Published by AuthorHouse 07/11/2019

ISBN: 978-1-7283-1893-6 (sc)
ISBN: 978-1-7283-1894-3 (e)

Print information available on the last page.

This book is printed on acid-free paper.

authorHOUSE®

Contents

Dedication page

This book is dedicated to everyone that contemplates the beauty of the Earth, the forest as trees alive breathing, feeling sunshine speckled on their arms in the early dawn. Embracing all creatures with the imagination of a child.

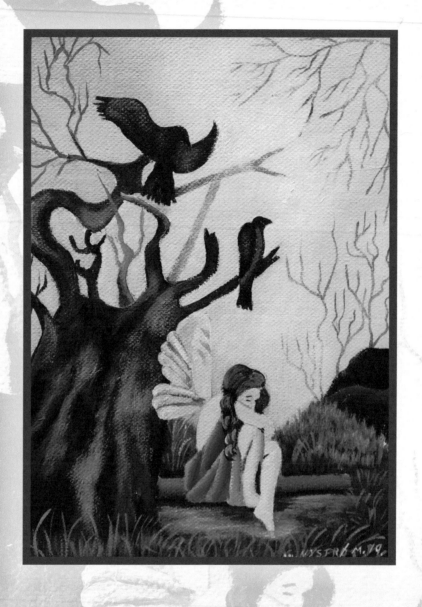

Already the once sweet-watered streams, most of which bore Indian names, were clouded with silt and the waste of man; the very earth was being ravaged and squandered. To the Indians it seemed that these Europeans hated everything in nature - the living forest and their birds and beasts, the grassy glades, the water, the soil, and the air itself...

Dee Brown, Bury My Heart At Wounded Knee

"A Flower Tiny"

*I am glad I will not be young in a
future without wilderness...
Aldo Leopold*

*A flower tiny grows alone,
No garden near to call its' home...
As petals red in sadness sway,
To winds of silence on
Display...*

*Sparkled beams in morning dew,
Wake flower tiny's day anew...
Bees of honey daily greet,
This flower tiny's nectar
Sweet...*

*Alone a flower tiny grows,
Scenting winds as breezes blow...
Petals red in morning's dew,
Swaying there 'neath
Skyways blue...*

*To winds of silence on display,
A flower tiny died today...
No bees of honey there to greet,
A flower tiny's nectar
Sweet...*

*A flower less 'neath skyway blue,
Where flower tiny brightly grew...
To winds of silence on display,
Roadways built all painted
Gray...*

*Flowers tiny grow alone,
Seeking ground to call
Their home...*

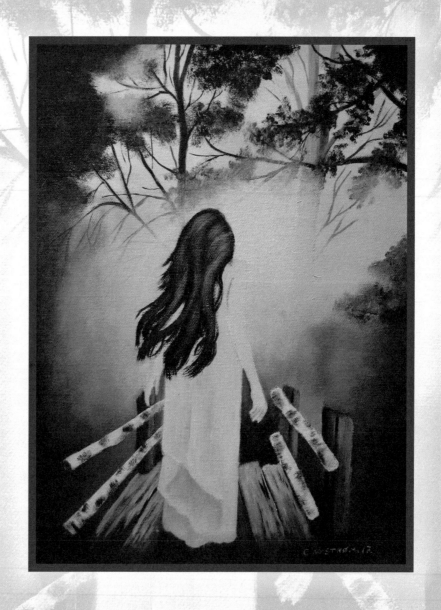

Weeds are just someone else's flowers...

Anthony T. Hincks

"A Weed Unknown"

When weeds go to heaven, I think
they will be flowers...
L.M. Montgomery

Bright there grows in scented breeze,
A weed unknown by woodland trees...
Petals blue they fragrant there,
Alone it grows so sweet
And fair...

Twirling round on stems of green,
Bluish gowned in woods unseen...
Beckons there the honeybees,
This weed unknown by
Woodland trees...

Unnamed not known this weed of blue,
By yonder woods no longer grew...
Deemed a weed by pruners there,
Alone it died so sweet
And fair...

Beckons not the honeybees,
The forest gone and woodland trees...
No petals blue in woods unseen,
Unnamed or known in
Forest green...

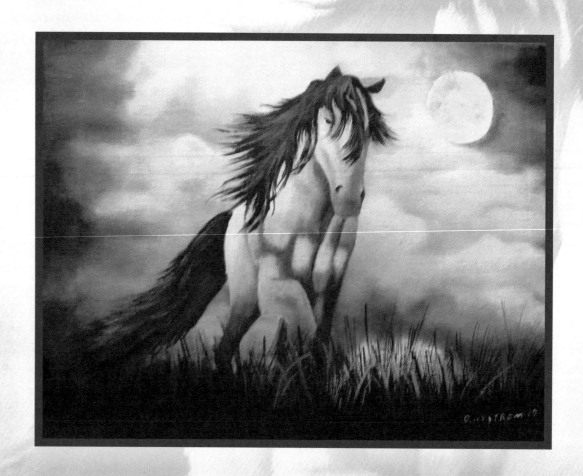

A little while I will be gone from among you, when I cannot tell. From nowhere we come, into nowhere we go...What is life"

It is the flash of a firefly in the night. It is the breath of a buffalo in the wintertime. It is the little shadow which runs across the grass and loses itself in the sunset...

Crowfoot (Chief) 1830-1890 Blackfoot.

"A Whispered Neigh"

When God wanted to make the horse, he said to
the South Wind, "I want to make a creature of
you, condense"...and the wind condensed...
Emir Abd-el-Kader

Hoof- beats I hear them fade away,
Beneath the moon a whispered neigh...
A waking dream or vision there,
A whispered neigh in
Distant air...

Blowing winds in silence cry,
As shadows walk and hoof beats die...
Astride their mounts +o'er hallowed ground,
Spirits ride with lances
Bound...

A waking dream or vision there,
A whispered neigh in distant air...
Astride their mounts the shadows cry,
Where mustangs roam and
Spirits sigh...

Away they fade a whispered neigh,
Beneath the moon where shadows lay...
With lances bound the spirits there,
Astride their mounts in
Distant air...

As shadows walk and hoof-beats die,
Blowing winds in silence
Cry...

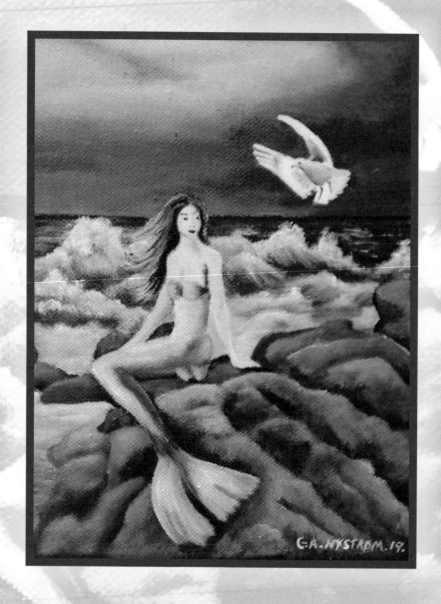

I'm always happy when surrounded by water. I think I'm a mermaid or I was a mermaid...I feel born again when I get out of the ocean...

Beyonce Knowles

"As Dolphins Dance Upon the Sea"

There's nothing more beautiful than the way
the ocean refuses to stop kissing the shoreline,
no matter how many times it's sent away...
Sarah Kay

Beneath the waves a streak of gray,
Above them there the dolphins play...
With knowing eyes a clown is he,
As dolphins dance upon
The sea...

Faint their shadows fade away,
With starlight sparkles on display...
Captured moonbeams chaste and fair,
Lighting mermaids ocean
Lair...

Song of midnight laid to sleep,
Waking mermaids from the deep...
As dolphins dance upon the sea,
With knowing eyes a
Clown is he...

Twirling gaily winking there,
Kissing mermaids in their lair...
Awake! Awake they seem to say,
Above them dolphins again
At play...

By shores of sand behind white dunes,
Sing the mermaids ocean tunes...
With knowing eyes a clown is he,
As dolphins dance upon
The sea...

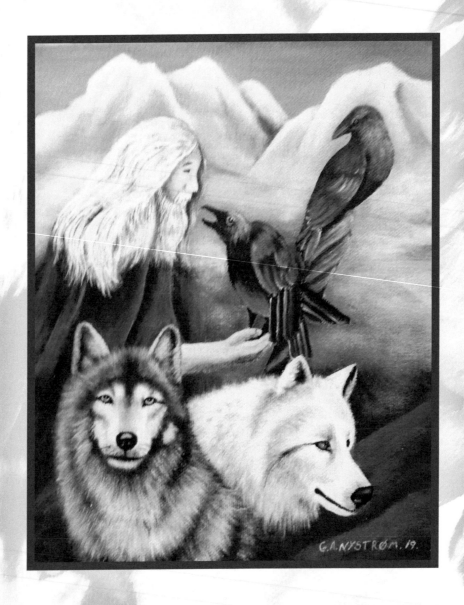

Wildness is the preservation of the world...

Henry David Thoreau

"Away! Away You Human Child"

*Humankind must begin to learn that the life of an
animal is in no way less precious than our own...
Paul Oxton*

Blooms no rose to fragrant air,
No tigers growl in empty lair...
Willows weep for leaves not green.
No echoed howls of wolves
Unseen...

No flowers wild in meadows bare,
Empty seas no fishes there...
Kneeling fairies forest queens,
Cry now aloud for woods
Not green...

Away! Away you human child,
Away they fade the creatures wild...
Immortal ravens haunting there,
As fairies cry in meadows
Bare...

No more to watch an eagle fly,
No more to see a starry sky...
No blooming rose to fragrant air,
No tigers growl in empty
Lair...

Away! Away you human child,
Away they fade the creatures
Wild...

G.A.NYSTRØM. 19.

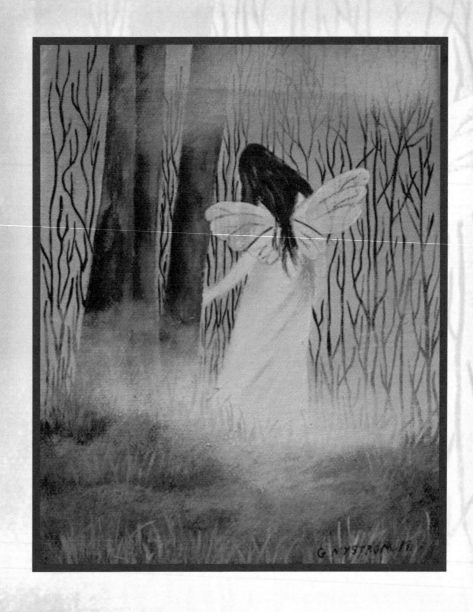

A flower blossoms for its own joy...

Oscar Wilde

"Black-Eyes of Susan"

*And don't think the garden loses its
ecstasy in winter...it's quiet, but the
roots are down there riotous...
Rumi*

*Susan's eyes with blackened hue,
Scents sweet the air 'neath skyways blue...
Her kindred leaves on slender stems,
Gleam they with dew these
Bonnie gems...*

*From their bed in dawn arise,
As Susan wakes the darkness dies...
Her petals there in morning's mist,
Gleam they with dew where
Sunlight kissed...*

*Majestic she with yellow crown,
Enticing bees with fragrant gown...
Scents sweet the air 'neath skyways blue,
Susan's eyes with blackened
Hue...*

*Weeps she not in winters cold,
Beneath the snow her crown of gold...
Asleep she waits for spring anew,
Awake her eyes 'neath
Skyways blue...*

*From their bed in dawn arise,
As Susan wakes the
Darkness
Dies...*

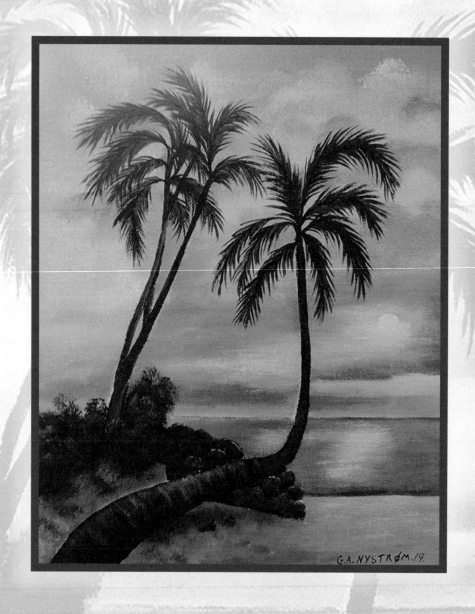

*Grey rocks, and greyer sea, and surf along the shore – and in my heart
a name my lips shall speak no more...*

Charles G.D. Roberts

"By the Sea"

Hark now hear the sailors cry, smell
the sea, and feel the sky...let your soul
and spirit fly...into the mystic...
Van Morrison

Crash the waves on moon-bleached sand,
As twinkled light in fairy lands...
The silent palm on shadowed coast,
By the sea a swaying
Ghost...

Like a bell tolling nigh,
Sea-foam sprays 'neath darkest sky...
Secrets they yet whisper not,
Beneath their waves time
Forgot...

Haunting still on shadowed coast,
By the sea a swaying ghost...
The silent palm in breezes blown,
Its fairy lands unseen
Or known...

By the sea in lands forlorn,
On moon-bleached sands the stars adorn...
Whispers not the secrets keep,
Beneath the waves where
Pirates sleep...

Sway the palm in silent breeze,
As sea-foam sprays through
Ghostly trees...

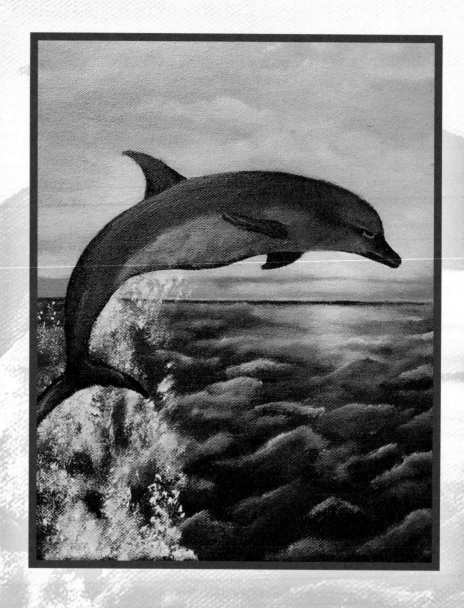

There is, one knows not what sweet mystery about this sea, whose gently awful stirrings speak of some hidden soul beneath...

Herman Melville

"Dreaming with Dolphins"

*Hark, now hear the sailors cry, smell the sea, and feel
the sky. Let your soul and spirit fly...into the mystic...
Van Morrison*

*Waking from my dream-state,
In my bed, soft feather'd white...
Mermaids there were swimming,
On dolphins in
Delight...*

*Beneath the foaming waters,
By diamond-studded shores...
Dolphins danced beside me.
Behind my bedroom
Doors...*

*With scales of tinted turquoise,
On dolphins there they ride...
Now swimming with the mermaids,
Each night by oceans
Tide...*

*Waking from my dream-state,
Behind my bedroom doors...
Dolphins danced beside me,
On diamond-studded
Shores...*

*Whispers from my dream-state,
As mermaids beckon me...
Triumphant now the dolphins,
Dancing out to
Sea...*

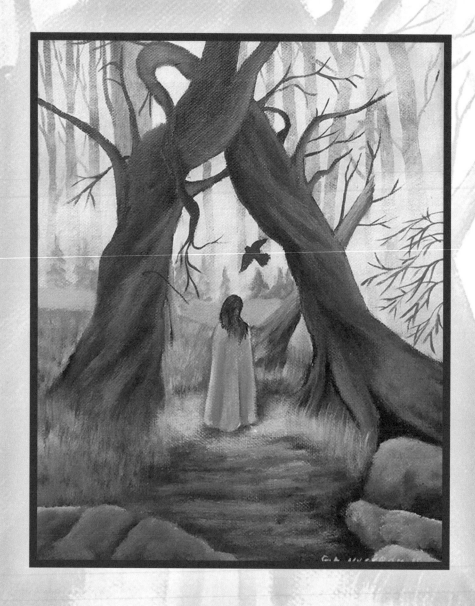

There are nights when the wolves are silent and the moon howls...

Ge

orge Carlin

"In a Forest Time Forgot"

I am glad I will not be young in a
future without wilderness...
Aldo Leopold

What speckled-breasted whippoorwill,
Sadly sings from yonder hill...
A hidden poet we know not,
In a forest time
Forgot...

Gold are the rays in dawning's morn,
On scented fields dewdrops adorn...
Shadows fade to midnight yore,
Rays twinkle there on
Forest floor...

Alone his songs in silence still,
Sings sad this speckled whippoorwill...
Seeing not the coyotes prowl,
Hearing not a wolv'n
Howl...

As shadows fade in dawning's morn,
On scented field dewdrops adorn...
A hidden poet time forgot,
In a forest we know
Not...

Silent notes in woodlands bare,
Gold are the rays that twinkle there...
Sings no more our whippoorwill,
As silence sounds from
Yonder hill...

A hidden poet we know not,
In a forest time
Forgot...

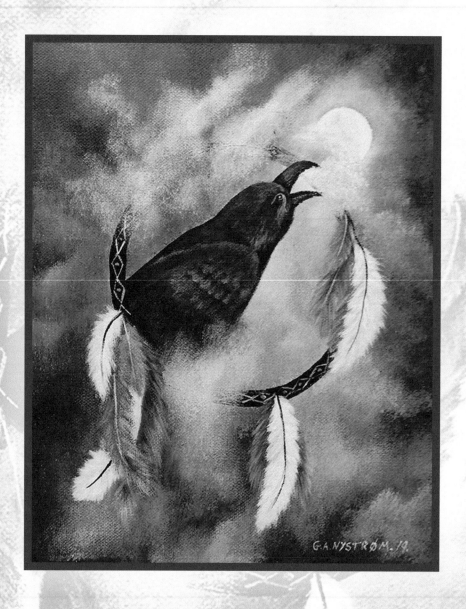

The raven is called "Keeper of Secrets" and like all birds is a messenger between the heavens and earth. He has the ability to bend time and space for the perfect moment at the right time...

Animal Spirit Guide

"Keeper of Secrets"

Quoth the raven "Nevermore"...
Edgar Allen Poe

In mountains, fields and valleys there,
Behold the raven's flight in air....
Moon-shadows sphere pierce not the sky,
When night is bare and ravens
Fly...

Palest clouds in misted eve,
Moon-shadows sphere seems still to grieve...
Spirits yet with lances bound,
When ravens fly o'er
Sacred ground...

Echoed drums from long ago,
On whispered winds that cease to blow...
In mountains, fields and valleys there,
Behold the raven's flight
In air...

Weeps spirits sad with lances bound,
On mustangs ride o'er sacred ground...
Away! Away the ravens fly,
In dark of night and
Misted sky...

Echoed drums from long ago,
On whispered winds that
Cease to blow...

G.A.NYSTRØM.19.

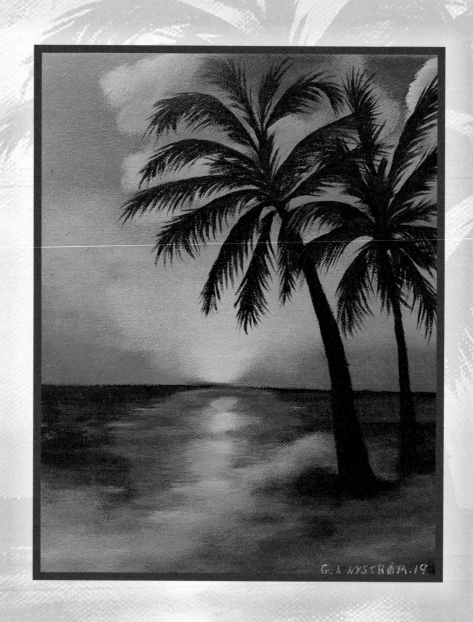

The sea, once it casts its spell, holds one in its net of wonder forever...

"The Dance of Mermaids"

There is no one knows not what sweet mystery
about the sea, whose gentle awful stirrings
seem to speak of some hidden soul beneath...
Herman Melville

Whispers there the shells to me,
Tales echo soft beneath the sea...
Dancing mermaids crimson-scaled,
Where ghostly pirates once
They sailed...

Beckons shore-line "come to me",
Tales echo soft beneath the sea...
Dancing maids forever more,
Listen they by oceans
Shore...

Beneath the sea-waves echo tales,
Shipwrecks lay with mast'ed sails...
Shadows ghostly pirates there,
Waking not in mermaids
Lair...

Beckons shore-line "come to me",
Where mermaids dance beneath the sea...
Shells they whisper pirate tales,
Of haunted ships with
Mast'ed sails...

Ghost of pirates wait for me,
Where mermaids dance
Beneath the
Sea...

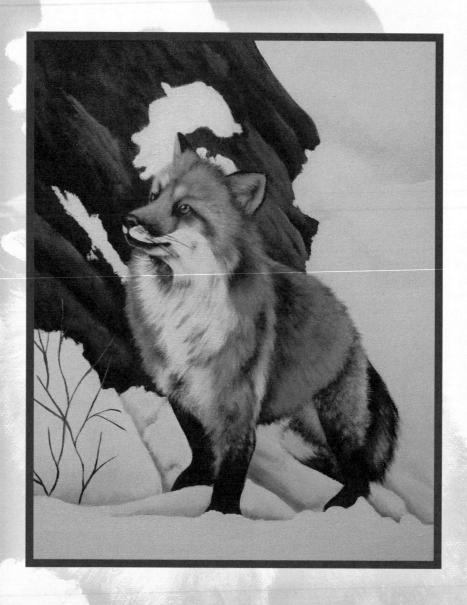

When the groundhog cast its shadow, and the small birds sing, and the pussy willows happen, and the sun shines warm, and when the fox smiles upside down, and the peepers peep...then it's spring...

Margaret Wise Brown

"The Fox in Spring"

*...and then, I have nature and art and poetry,
and if that is not enough, what is enough...
Vincent William van Gogh*

Through grassy meadows wild and bare,
Springtime scents the fox's lair...
As bells of blue in faint disguise,
Wave to winter, their
Goodbyes...

Where mountains shade their forest friends,
With rivers flowing round the bend...
As doves of mourning softly gray,
Watch fox's kits in daylight
Play...

Now, nature wakes this springtime scene,
To woodlands barely turning green...
As bells of blue in faint disguise,
Wave to winter, their\
Goodbyes...

As black eyes peer inside their lair,
In grassy meadows, wild and bare...
'Neath mountains cap'd in winters snow,
Where bells of blue in springtime
Grow...

As doves of mourning softly gray,
Watch fox's kits in daylight
Play...

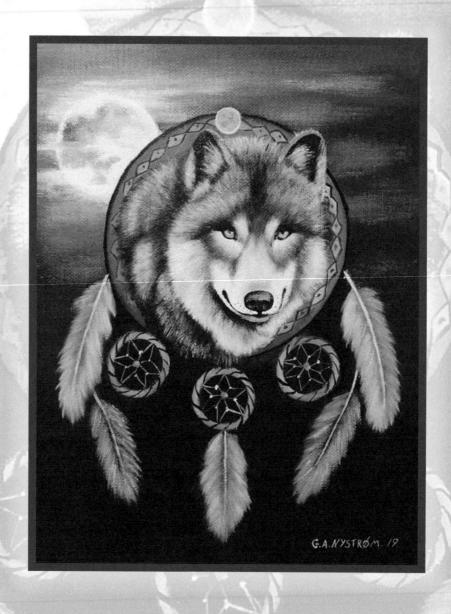

The legend of the Dreamcatcher; A Chiipewa Legand....A spider thanked "Nokomis" a grandmother for protecting him from her grandson. In return for saving his life, he gave her a gift. "See how I spin? For each web will snare bad dreams, only good dreams will go through and be remembered...forever remember Nokomis whenever you see a spider's web...it is I, protecting you...

"The Spider & the Dream-catcher"

*I'm a dreamer. I have to dream and
reach for the stars, and if I miss a star
then I grab a handful of clouds...
Mike Tyson*

A spider weaving sitting there,
Catching dreams from everywhere...
While snuggled sleeping on the floor,
Grandmother dreams of
Dreams before...

Howling wolves this wintry night,
As spider spins till early light...
Weaving webs to nature's cries,
As dreamers dream with
Sleepy eyes...

Threads of silver twinkle bright,
Weaving threads this wintry night...
Spins the spider sitting there,
Catching dreams from
Everywhere...

Soft the howls 'neath crescent moon,
Softly humming nature's tune...
Sleep grandmother never fear,
Safe you are with
Spider near...

Dreamers dream as dreamers do,
While spider catches dreams
For you...

G.A. NYSTRÖM. 19

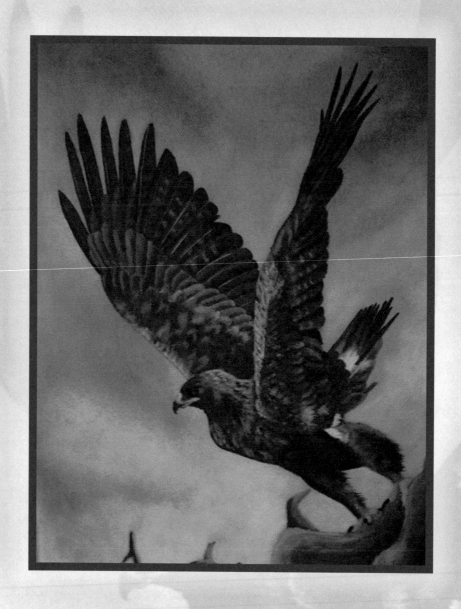

Another May new buds and flowers shall bring; Ah! Why has happiness
no second spring...

Charlotte Smith

"This Month of May"

At last came the golden month of the wild folk-
honey-sweet May, when the birds came back, and
the flowers came out, and the air is full of the
sunrise scents and songs of the dawning year...
Samuel Scville Jr.

From mountain-tops to meadows bare,
Sleeping yet the flowers there...
Echoes still the eagle's flight,
As birds and bees themselves
Alight...

Sing sweet birds in month of May,
Grieve no more the bees delay...
Late of spring in meadows bare,
Sleeping yet the flowers
There...

Peeks soft a petal ruby-red,
Awaking from It's wintry bed...
With delight the bees arrive,
Scurry they from hive
To hive...

From mountain-tops to meadows green,
Lovely there this forest scene...
Flighted eagles on the wing,
When peeking flowers
Welcome spring...

So sing sweet birds without delay,
With speckled breast...
This month of
May...

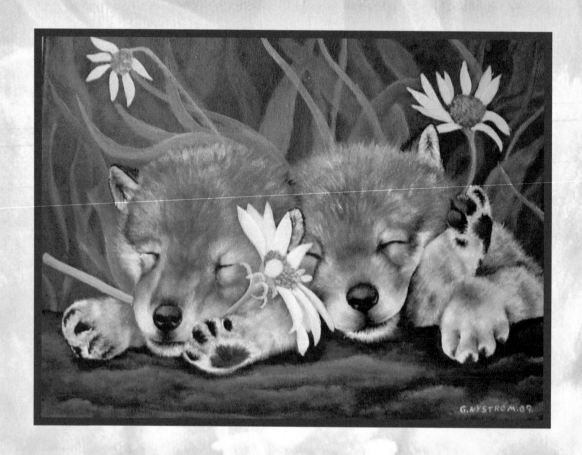

...there is something which impresses the mind with awe in the shade and silence of these vast forests. In the deep solitude, alone with nature...we converse with God...

Thaddeaus Mason Harris

"Through the Woodlands Slowly"

It is when the forests stop breathing
that man bids farewell...
Anthony T. Hincks

In morning's fragrant scented mist, dewdrops twinkle unaware,
Awaking petals spring-times host, tinting meadows fair...
As tolling bells of evening dies, fading with the night,
Canopy of forest glows, gowned in
Greenish light...

Blooming yellow'd daffodils, neath sunbeams dawning rays,
Brown chickadees and sparrows on scented lilacs play...
Peeping buds of myrtle, peek with sleepy eyes,
By shores of sea-birds winging in
Morning's early rise...

Those lazy dozing lizards by streambeds flowing nigh,
With patient spiders waiting for the wayward fly...
Springtime claims her forest with tender majesty,
Waking sleeping willows, while nudging
Oak'n tree...

Through the woodlands slowly, on leaves of tender green,
Rays of morning cradle, what God Himself has seen...
Inside us hear the silence in places all alone,
As creeping slow the brambles in quiet
Call home...

Buds of myrtle peeping awaking new to spring,
As fairies fragrant flowers with
Kisses on the wing...

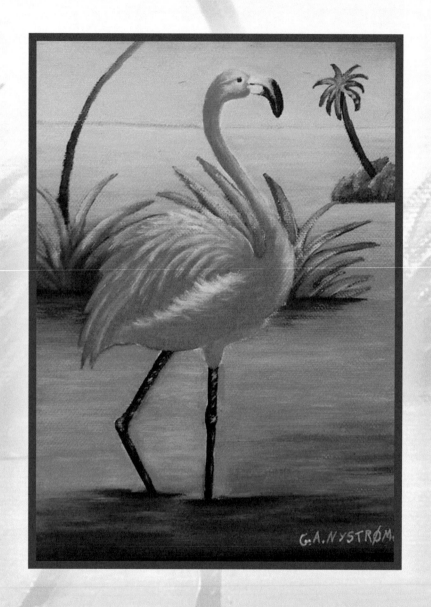

live in each season as it passes; breathe the air, drink the drink, taste the fruit, and resign yourself to the influence of the earth...

Henry David Thoreau

"Wade the Everglades"

...and then, I have nature and art and poetry,
and if that is not enough...what is enough?...
Vincent van Gogh

Sun bleach'd sands whitely glow in Florida's everglades,
As twilight's nodding flowers sleep in evening's shade...
Seabirds wadding silently in turquoise colored seas,
By dancing flies of butter and singing
Bumblebees...

Frogs in bullish cadence echo music 'neath the moon,
Where trees of cypress dying forever cease to bloom...
Sand hill cranes with ibis wings spreading in display,
Embraces midnight's chorus in mingled
Shades of gray...

Sea-sides simple symphony with singing bumblebees,
Flamingos wading silently in turquoise colored seas...
While lazy little lizards doze with open eyes,
'Neath Florida's golden sunsets with
Painted-purple skies...

Flamingos there with ibis wade the everglades,
As twilight's nodding flowers sleep in
Evening's shade...

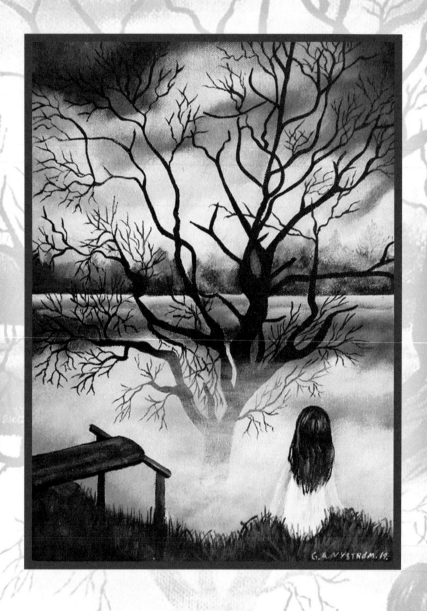

We kill all the caterpillars, then complain there are no butterflies...

John Marsden

"Weeps the Meadows"

Climb the mountains and get their good
tidings, nature's peace will flow into
you as sunshine flows into trees...
John Muir

Weeping meadows haunts the hills,
No sparrow's song or whippoorwills...
Woodland's pines yet echo nigh,
Light are the winds when
Spirit's cry...

O'er mountains simple majesty,
Eagles shadow woodland's tree...
Wings outspread pursuing flight,
Between the morn and
Evening light...

Heavy now the scented flowers,
As meadows weep these secret hours...
Away, away sweet birds of song,
No more, no more do they
Belong...

Haunts the hills and far beyond,
Croaks no frog by golden pond...
O'er woodland's tree the eagles fly,
Light are the winds when
Spirit's cry...

Echo yet the songs unheard,
Lost in time these little birds...
Weeping meadows haunts the hills,
No sparrow's song or
Whippoorwills...

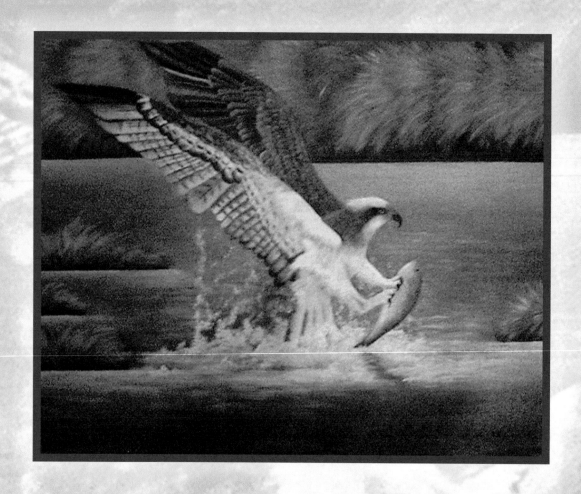

And the spring arose on the garden fair. Like the spirit of love felt everywhere;

And each flower and herb on Earth's dark breast, rose from the dreams of its wintry rest...

Percy Bysshe Shelley

"When Not the Willows Weep"

April's air stirs in Willow-leaves...
as a butterfly floats and balances...
Matsuo Basho

Frogs in chorus singing in bogs on logs unseen,
Away the winter's fleeing, in meadows
Barely green...

Williams sweet now fragrant nudging roses red,
Scenting breezes blowing around
Their garden's bed...

No longer are they weeping, ancient willows green,
In the sunlight dancing as frogs
In chorus sing...

Blooming yet the daisies where bright fly butterflies,
Enchanting mountain meadows
Wearing springs disguise...

Singing songs of spring-time, when willows not they weep,
But in the sunlight dancing, as awake the
Frogs from sleep...

Williams sweet now fragrant beckon butterflies,
As away the winter's fleeing now
Wearing springs
Disguise...

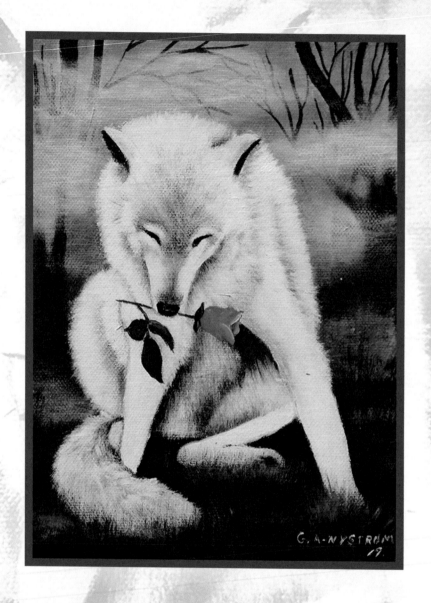

For every thorn is just as essential to the longevity of the plant as the blossoms...

S.R. Ford

"When Roses Die"

But he who dares not grasp the thorn
should never crave the rose...
Anne Bronte

Fierce the winds as a tempest blows,
As shadows dance 'neath springs new rose...
Soft the petals to earth they cry,
Away to fade when roses
Die...

Hide sweet blooms yet not red,
As fierce the winds 'round garden's bed...
When blows a tempest caring not,
Pluck soft the petals time
Forgot...

Crimson-tipped where hides the thorn,
On slender-stems with buds unborn...
Leaves of tiny green shall shield,
When falls soft petals far
A-field...

Stained red the tips when roses die,
Away to fade in fields they lie...
Specter-thin they fragrant yet,
When blows the winds sweet
Blooms forget...

Amid the storm cries the rose,
As fierce the winds in summer blows...
Away to fade with buds unborn,
Crimson-tipped still hides
The thorn...

G. A. NYSTROM

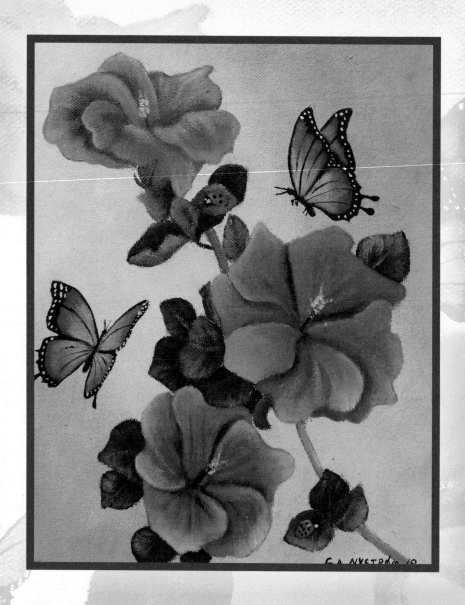

Sometimes referred as the ladybird beetle, they are considered lucky to have one light upon us, and the killing of one unlucky. We are to make wishes upon them, resting them upon the open palm...when they fly off the wish is then released into the wind...

"With Crimson-Colored Spotted Wings"
(Maria Fly-Fly)

May you never become so cynical that
you let a star fall without it's wish...
Nicole Lyons

In groves of scented myrtle by fragrant winds that blow,
Wandering flies of dragon by streams that ever flow...
As daisies black and yellow brighten gloomy glades,
With crimson colored spotted wings,
A lady in the shade...

O'er meadows greening glory in secret twilight's hour,
As beams of kissing sunlight shelter sleepy flowers...
Daisies black and yellow welcome coming night,
There in the shade a lady on evening's
Fading light...

Into my palm she alights,
My wish she waits from me this night...
By scented blue forget-me-nots,
Her crimson wings with
Polka-dots...

Western skyways purple'd while flaunting daylight's blue,
There in the shade a lady where tiny wishes grew...
Her crimson-colored spotted wings flutter as she flies,
Away to home she saunters on
Evening's fading skies...

With crimson-colored spotted wings a lady in the shade,
There...into the wind releasing hopes
And wishes
Made...

Printed in the United States
By Bookmasters